T0171335

# Things That Never Were

A collection of poems that have
strayed from the beaten path

Brian Gudmundsen

authorHOUSE®

*AuthorHouse™*
*1663 Liberty Drive*
*Bloomington, IN 47403*
*www.authorhouse.com*
*Phone: 1-800-839-8640*

*First published by AuthorHouse  2/23/2010*

*ISBN: 978-1-4490-8082-2 (sc)*

*Printed in the United States of America*
*Bloomington, Indiana*

*This book is printed on acid-free paper.*

*To my daughter, who showed me the many depths of my soul.*

For those of you who need a helping hand...
For those of you seeking distant lands...
This book is for you.

For those of you who live for fun...
For those of you who get things done...
This book is for you.

# HOPE

"No vision and you perish; No Ideal, and you're lost; Your heart must ever cherish Some faith at any cost. Some hope, some dream to cling to, Some rainbow in the sky, Some melody to sing to, Some service that is high."

~ Harriet Du Autermont

# 15 Soldiers

### One

little soldier standing all alone. One little soldier that wanted to go home.
But when that soldier heard the gun, he knew that he was on the run.

### Two

little soldiers talking amongst themselves, trying to escape
from this living hell. Two little soldiers, one was nearly shot.
Though the enemy found them, they were never caught.

### Three

little soldiers planning their escape, made a break for the enemy's gate. The
guns were fired at all three, but the little soldiers made it through the trees.

### Four

little soldiers heard all the gunfire; they wanted to run more, but
they began to tire. Four little soldiers trying to catch their breath,
heard the guns get closer, and knew they couldn't rest.

### Five

little soldiers at the end of their rope. They all saw no point
in having any hope. But a helicopter came and saved all
five. They thanked their God for still being alive.

## Better Day

You force yourself to crawl out of bed, part of you wishing that
you were dead. Looking forward to nothing at all, watching the
phone, knowing no one will call. It's days like these that cock
the gun, all the while hoping that someone will come.

This is a song for the heart-broken, the outspoken, and those hoping for relief.
Though things are blue, you'll make it through, so just hold out for a better day.

What's a matter with you? They broke your heart? Well that doesn't give you
the right to rip yourself apart. Just because they yelled doesn't mean that you
failed; Just because you've lost all hope, doesn't mean you tie the rope. Are you
up or are you down? Do you wish there was someone around to tell you that
everything's gonna be alright? Don't you just wish they'd turn on the light?

This is a song for the heart-broken, the outspoken, and those hoping for relief.
Though things are blue, you'll make it through, so just hold out for a better day.

## Dreaming Away...

Solitude...
A comforting emptiness, a shawl of never-ending dark wrapping itself around
you. Becoming one with you; <u>becoming</u> you. Swallowing you whole, into a
perpetual calm; a sea of unwavering comfort. A point between the brink of
dusk and dawn - a point in time that neither exists nor is confined in space.
Blank stare of total comprehension: complete understanding of abstract logic.
Fleeting ecstasy that would last forever, if only we knew how to contain it.
Deep reaches of our mind that we didn't know were there... Unseen, unheard
of prophesies of untold explanations. Unending and unnerving, the shackles
of mortality released. One becomes many - many become one. A rapture of
peace breaks out like requiem - the choir sings out to the newly converted. As
unopened eyes witness the truth -- they second guess their consciousness.

## Far Away Wonders

The ocean blue surrounds the shore, a tranquil breeze is blowing. The large palms dancing in the wind, the stirring sand, ever knowing.

Echoes of children from far away past flow with the branches of the moving trees. And as the current collides with the beach, the shells sift as they please.

Here on the beach where spirits roam, inspiration is in its purest cast. Imagination, reality, synonymous now, close your eyes, feel the peace at last.

## Hero's Call

When destiny calls, will you be there to heed? A hero is something this world desperately needs. To help us through all the bad times and good, like any good hero always should. To help us in our times of need, help those that need it, and the hungry feed. What does it take to be a hero you're asking? You want to join the ranks of the glory-basking? Despite popular belief, it does not take much. But it takes determination, charisma, and such. You need a smile on your face, good thoughts in your mind. You don't need super powers of any kind. Just helping your neighbor take out his trash, or helping a friend when he's in need of cash. These are the things that make you a hero, as long as your pride is equal to zero. You cannot get a swelled head when serving man, for no hero I know wants to or can. So from this day forth, put your differences aside, help one another, by the hero's rules abide.

## Nature's Wish

The eagle soars across the sky; I wish, oh wish that I could fly.
Soaring across the river blue, sharing the wind with only a few.
Catch a snack on the move - live each day with nothing to lose.

The trout dives deep on a whim; I wish, oh wish that I could swim.
Drifting through the river blue, sharing the water with only a few. Swim
with a group or swim alone - call wherever your very own home.

The monkey swings on his vine, I wish, oh wish that I could climb.
Hanging over the river blue, sharing the branches with only a few.
Leap and bound from tree to tree - live every day completely free.

## Requiem

This requiem is for days that have passed. For the morrows that were never cast. Days that we spent pouring out our hearts. Days that were spent falling apart. Days like the days just before that. Days like the days that felt like a trap. Days upon weeks that never did mend. Weeks upon months that never did fend. Months upon years caused our lives to bend. And as of late you just beg it to end! But this is the requiem for all the days past. Those seeking peace will find peace at last. And as dusk begins to draw itself nigh, the darkening colors swirl in the sky. As darkness takes over, the moon gives a glow. the passage of time tends to go slow. And just for an instant, you can't see, hear, or smell. But just for an instant, you know all is well.

## Roller Coaster Girl

She's got her ups and downs, her all arounds; her smiles and frowns. I'm strapped in tight for a wild ride, but to where I can't decide. When I talk to her, my tongue is in knots - try and act suave, but I know I'm caught. Close my eyes, take my heart for a drop. She's a roller coaster that I don't want stop.

I would break the barrier of sound, just to have her around. I would break the barrier of light, just to hold her nice and tight.

## Slipstream

It starts with a leap. Down the rabbit hole, so to speak. Close your eyes
for just a tick. Or squeeze my hand just for kicks. You're no longer alone
on this ride. Ticket for two down the proverbial slide. You may think
you have to go this alone; but that's not something that I condone.

I'm in it to win it; I'm by your side. I'll always be with you, no
need to hide. It takes faith, trust, and a bit of guile. But you're
dressed to kill, and you've got style. You also have a little bit
of my heart. Whenever you're ready, I'm ready to start.

# Someday

Someday I'll catch you when you fall, someday I'll pick you up when you crawl.
Someday is a day not too far away. Someday I promise that I'll never stray.

When the world breaks down and it's just the two of us, just take my
hand, there's no time to fuss. Close your eyes and take a leap with me;
close your eyes, and we'll be free. When the world breaks down and it's
just you and I, I'll wipe your tears if you start to cry. Hold your breath
and take the plunge with me; hold your breath and we'll be free.

Someday you'll be back in my waiting arms, someday I'll keep you safe from
harm. Someday I'll get to call you mine, someday I'll send shivers up your spine.

Someday I'll be your only one, someday you'll let me be your source of fun.
Someday I'll give you the time of your life, someday I'll take away all your strife.

When the world breaks down and it's just me and you, just take my hand,
and we'll see this through. Close your eyes and take a leap with me;
close your eyes and we'll be free. When the world breaks down and we're
the last around, I'll comfort you when you get down. Hold your breath
and let's take a stand; we'll escape this place and fly to Neverland.

## Sticks

Sticks and stones can break up bones, but her words will cut you
deeper. I'd go through this hell and back, just to be her keeper.

I'd put up with the madness, I'd put up with the lies. I'd be there for her
everything, and hold her when she cried. There is no rhyme to reason, no
thought put in this plan. Just a drive to save her, and be her helping hand.

Sticks and stones will break up bones, but her words will cut you
deeper. I'd go through this pain and back, just to be her keeper.

I'd put up with the sadness, I'd put up with the fights. I'd be there for her
anything, and make everything all right. There is no reason to this rhyme, nor
well-thought out design. Just a drive to save her, and finally make her mine.

Sticks and stones have broke my bones, but her words have cut me
deeper. I'd go through all of this again, just to be her keeper.

## The Rose

Beauty unmatched, like from a dream. Like a puzzle, is more than it seems.
An Irish rose, one of a kind. Grown in a place inside the mind. Its petals
shimmer in the sunlight. It glows ever faintly whenever it's night. Only
few have seen the actual rose. If it truly exists, nobody knows. The sight
of it is said to make you smile. Some would travel thousands of miles just
to catch a glimpse of the thing; rumor has it, it makes your heart sing.
As for me, I know the truth of it all. I was the one that broke its fall.

# Unchained

Locked doors, opened eyes, looking for a way inside. Closed
lips, opened minds, just needing to confide.

What's the point when you're outside always looking in? What's
the point when nothing goes right; when you ever win? Is there
a point to going on? If there's a point it's now long gone.

You think life's unfair? You think you have it hard? The
key to a successful bluff is holding all the cards.

Your life could be much worse off, I guarantee you this. Good
times always go too soon, bad times are never  missed.

Locked hearts, closed eyes, seeking the way no more. Locked
gaze, closed minds, screaming till my lungs grow sore.

What's the point when nothing's right, when you can never win? What's the
point of being on the outside always looking in? Is there a point to all this pain?
Is this another of your confusing games?

You think life's unfair? You think you have it hard? The
key to a successful bluff is holding all the cards.

Your life could be much worse off, I guarantee you this.
Good times always go too soon, bad times are never missed.

Suck it up, wear a smile, things aren't always worse. If you
find yourself all saddened, just write another verse.

# Under The Skin

The whole thing started with a passing glance. Swallowed his nerves,
asked her to dance. His head was swirling in his heart; he stumbled
over words before he could start. Her eyes lit up with an amber
glow - when your heart skips a beat that's when you know.

It's like the rain that refuses to fall. The runaway train that
will never stall. You catch your breath just to lose it again;
that's when you know they're under your skin.

She always watched him from afar, like a twinkling little star. So much to say,
but she never said a word. She never took the chance to find what he preferred.
She had given up until their eyes first met - the butterflies caused her heart to jet.

It's like the rain that refuses to stall. The very last leaves
that refuse to fall. You catch your breath just to lose it again;
that's when you know they're under your skin.

From the day they could walk they were always friends. Supporting each
other to the bitter end. Then came the day that he noticed her; he never
even said a word. He threw his caution to the wind. That's how he knew
she was under his skin.

## Unspoken Pledge

I pledge allegiance to this flag, and I pray to God that I don't lag. I'll defend my troops through tooth and nail. I'll protect this land without fail. Stalwart fighting to the bitter end; if tragedy strikes, I will defend.

To the Republic in which I stand for, I swear to protect you to the core. And to the people that fought before, I promise not to ask for more. One America that's united and free. All of this started with one little tree.

Indivisible we stand together on this land, fighting for our Uncle Sam.

Here is where our liberty ensues; here is where our justice pursues. I promise to you that if I fall, I will always stand one for all.

## You and Me

Fallen from above, these days they never end. But one
thing makes it livable, and that is you my friend.

Always there to catch me as I drift down cataracts. Always
there to stop me in the middle of my acts.

You're my dearest friend, we both know that it's true. You're
always there to lend a hand, and I'm always there for you.

I never want to lose you, I dread the day that comes. But
soon the fate will happen, and ruin all our fun.

Let's cherish all our moments, before that day arrives. Let's
vow to be such good friends, until the day we die.

Forever and ever, friends we'll be. And when the sun sets, it'll be you and me.

# DESPAIR

"To be thoroughly conversant with a man's heart, is to take our final lesson in the iron-clasped volume of despair."

~Edgar Allen Poe

## All Hollow's Eve

The shadows creep just like a spider, its hollow grip growing ever tighter. Echoes of voices that chill to the bone, beckoning you to join them in the unknown. The moon hides itself behind clouds so dark. Devils and demons shall leave their mark. Ghosts of the fallen that refuse to move on; their howling torment spell out a sad, empty song.

The night drags on, like a corpse on the move. The ghouls own the sky, keeping the mood. Screams rip the silence as life dawns a new day. The trickling sunlight scares the darkness away. With a sigh of contempt, the evil takes leave. It will simply bide its time until the next Hollow's Eve.

## Altruism Only Look Good On Paper

Don't mind me, I'm sitting this one out, there was never a towel to
throw in. I find myself not sleeping now, wondering how you've been.
I play the moments in my head, desperately seeking the reason.
Regardless of an explanation, it seems that I went out of season.

Altruistic outlooks aren't my cup of tea, but if you take my hand then they just
might be. Fool me once and the joke's on me. I'm not one to wait around and see.

It's about time I accept the fact that maybe I'm too naive; I refused to even
watch as you turned around to leave. You claimed it was time that we should
part ways, inside I screamed, begging you to stay. But for your sake or mine
I pretended to be strong. I never believed that what we had was wrong.

Altruistic outlooks aren't my cup of tea, but if you take my hand then
they just might be. Fool me once and the joke's on me. I'm not one to wait
around and see. Days down the road, you found the mistake. Maybe I
was never too good to be true. By then it was late, the holes had mended;
I forgot the reason that I stayed with you. Inside you screamed, and
begged me to stay. But the words never rolled off your tongue. My things
were packed, I was out the door, you and I were a love left unsung.

Altruistic outlooks are not your cup of tea, and if you hold my hand you will not
fool me. But more than once, and then we'll see just what you and I can really be.

## Blind America

Stop.
Take a look around at all the smiles and frowns of the liars and
clowns that drown out our suburban little towns. It's obscene how
unclean our morality gets. It's sad that the dog sits for the master
that pits against his own kin just to get under their skin.

Does it make you ill that people get their fill the super-sized way?
Are they even aware of how much they weigh? Not only have we
increased in girth, but we've grown in size from the time of birth.

It's times like these that bring us to our knees so that we may pray; postpone
our death for another day. Who needs a reason? We have the new season of
the sitcom of the month. Don't pull that stunt, or I'll simply be blunt. We're
boob-tube addicted, in denial slobs. A curly fry away from becoming blobs.

Do we even try to change our fate?
No.
Hell, we embrace it like a chocolate cake. God is in heaven, shaking his head.
All that is good is finally dead. Self-respect, may you rest in peace as we all
enjoy another piece of the pie chart. Ha, I don't even have the heart to tell
you all the truth. But what do I know? I'm just another wasted youth.

## Broken

Take my hand, say a prayer, break my heart if you dare. Cross the line, I'll end it all. Next time I won't catch you when you fall. Seasons end, as do we; sometimes I wish I could be free. So take my hand, say a prayer, break my heart if you dare.

Lights they dim, as have I. You keep saying that I made you cry. But that is anything but fact, you're simply putting on an act. The bridge between us has been burned. The field is changing, the tides have turned. Just take my hand, say a prayer, and break my heart, if you dare.

I always knew we'd never last, like every other in the past. I always knew it'd come to this, like a blade upon my wrist. Darkness coming, the end is near, hatred burning, too much I fear. Take my hand, say a prayer; break my heart, if you dare.

Anger spitting, fury blind, I never should've been that kind. I should've just passed you by. You're not the only one that cries. As my last breath escapes my lips, I feel my reality begin to slip. You took my hand and said a prayer. You broke my heart because I dared.

## Caged

Sometimes I stare out the window, a longing in my eyes.
I feel like a caged canary, eager to spread my wings and fly.
This room feels like a prison, though there are no locks on the
door. But still I feel so trapped like I never have before.

Freedom lies on the other side of a wicker fence. Why
I try to stay and lie makes no sense.

## Cliché

We've lost our minds but that's okay; who deems normal anyway?
Realities shattered to the floor, figments of friendships nevermore.
The breaking dawn has broke my soul. Will someone help me fill
this hole that you left so carelessly? Won't you ever let me be?

I played your game for far too long. I feel like Mario in
Donkey Kong. One too many barrels to the face;
I wish you'd just leave this place. Nobody wants you around
this town. Nobody wants to be your clown.
So go on, get up, and take your things. Travel the way that the blue bird sings.

A dusty road where you will tread, I care for you like the dead. I hope for
your sake you don't come back; I hope for my sake you stay on track. Just
keep on walking away from here - a very long walk off the shortest pier.
When you're gone, you'll fade away; just another heartbroken cliché.

## Comatose

I wake up to find a bitter taste in my mouth. It seems that my
plans have all traveled south. My vision is hazy; don't know where
I am. My body is lazy, refusing to stand. I cinch my eyes shut in an
attempt to wake up. It seems within hell, I am currently stuck.

Somebody please stir me from this treacherous scene. I've lost all
control in this picturesque dream. I hold my breath still in the hopes
that I'll stop. I shut my mind down to refrain from all thought.

Though my arms lack restraints, they refuse to stir. I rack my brain
over, merely seeking a cure. How did I get here? Who knows that I'm
gone? The echoes of chatter become a bittersweet song. Someone is here,
they're aware of my state. What did I do to invoke such a hate?

Somebody please stir me from this horrible game. I find myself lost
at understanding your aim. I hold my breath still in the hopes that
this ends. How much more torture could God possibly send?

Three figures stand over me, deciding my fate. Clearly refusing my
suffering to sate. Silent whispers reverberate deep in my head; what
if one of them were here in my stead? Have they no mercy for the
man on the bed? Clearly they wouldn't just leave me for dead?

## Daddy Dearest

To the man that I called father, this is for you, though why I bother. Our state of
dysfunction knows no bounds; at least it would if you were still around. I would
have settled for bastard status. You should have held on while you still had us.

Daddy dearest, your love meant so much. Always patient, you never cussed.
Then one day it all fell apart. Daddy dearest, why'd you break my heart?

Mom still swears up and down that you loved us. So tell me why you left
us in the dust. Don't you dare tell me it was the smartest thing. Your
protective lies will not lessen the sting. You packed your things, but
forgot your pride. How can I respect a man that runs and hides?

Daddy dearest, your love meant so much. Always patient, you never cussed.
Then one day it all fell apart. Daddy dearest, why'd you break my heart?

Maybe some day you'll see this was wrong. Maybe you realized it all along?
You may even try to make amends. I hate to say it, but this is the end. You had
your chance to play your role. I'm afraid it's too late for you to fill this hole.

## Confessions

A silhouette of a lie, a broken promise not to make you cry. I ring
my hands of this dirty deed. Someone who cares is what you need.
You really should shake your head in disgust. You shared hopes and
dreams and now they're crushed. It's really sad that things ended
this way. I pushed you all the time, but you begged me to stay.

But now I'm cutting the cord, splitting the tie; not even you should have
to live this lie. My mask removed, now my true face is shown. People
like me deserve to be alone. I should have seen this coming before I even
let this start. I'm sorry about the scar that I left on your heart.

## Deceived

Your promises look like lies; now I can't look you in the eye. You gave me the world, then stole it away. I want you gone, but I beg you to stay. This burning pain, the onset of hate - the empty preceding was just a bit late.

The whole mess is a tragedy, wrapped up in a shame. The illusion was shattered, and you're to blame.

## Fairy Tale

You and your illusion of happiness. I tried my best to fix
this mess. But the wounds are open, the scars are fresh-
And you wonder how things ended up like this.

Well let me share the story on page two, a fairy tale staring me and you.
How you had me backward bending, just to get my happy ending.

No magic pumpkins, or little men- This fairy tale will have
a different end. One where we will be far apart,
and we'll erase our words to get a fresh start.

Now let me share the story on page two, a fairy tale staring
me and you. How you had me backward bending,
just to get my stupid ending.

The jig is up, fairy tales aren't real. So tell me how that makes you feel. Does
it make you angry? Does it make you sad? I'm the best that you never had.

Let me share the story on page two, a fake fairy tale staring
me and you. Here I am, backward bending,
Now give me my happy ending.

# Fallout

I'm your fall out, your alternate escape route. I'm your
disappearing act when odds against you get stacked.

You use me, abuse me, to the point of no return. I'm battered, I'm bruised, to
the point that I should learn. But perfection is a state of mind, one in which
I don't have time. Work me down to the bone until I leave you on your own.

I'm your duck and cover when you try your best to outrun another.
I am your human shield out on the emotional battlefield.

You hide behind me all the time, yet you don't see it as a crime.
You pretend like you're hard to get, acting like you just lost a bet.
But perfection is a state of mind, one in which I don't have time.
Work me down to the bone until I leave you on your own.

I'll be your placed doubt, your alternative way out. I'm your up-
the-sleeve trick when you decide to give them the slip.

I'm growing tired of this cat and mouse game; I'm sick of you never taking the
blame. It's my turn to give the cat a try, but I don't think you'd let that fly.

You use me, abuse me, to the point of no return. I'm battered, I'm bruised, to the
point that I should learn. But I will never learn in time, because perfection is a
state of mind. You worked me down to the bone, so I'm leaving you on your own.

## Feeling Nothing

Promise me that you'll never change. I love the way you act so strange.
Come play with me and my head; when you're done, leave me for dead.
My rosy cheeks and my smile; there's no shame in my denial. I'll smile
and wave as you pass me by. You're not the only one who lies. You played
me like I was such a fool. You just walked on by at work and school.

So here I am, feeling nothing at all. Where were you when you answered the
call? If I close my eyes will you disappear? Keeping you is my biggest fear.

Watch my face lose it's cheer every time that you draw near. I paint my
smiles upside down because I'm not afraid to show my frown. You loved
to hate me, that is true. Even if I was there for you, though I probably
shouldn't have been. When I play your games I can never win. I counted my
chickens before they hatched - I needed you bad until I found the catch.

And now here I am feeling nothing at all. Where were you when you answered
the call? If I close my eyes will you disappear? Keeping you is my biggest fear.

As the curtain closed on your escapade, my body couldn't take it with the way it
was made. I fell to my knees with my eyes wide shut. Your words, so sharp, began
to cut. You dropped the oldest line in the book. You played yourself off as the
crook. Hoping that I would take the bait, your eyes began scanning for a different
mate. You expected me to fill with strife, but I can't wait till you're out of my life.

Now here I am feeling nothing at all. Where were you when you answered the
call? If I close my eyes will you disappear? Keeping you is my biggest fear.

# Imperfect Society

Jimmy was a soccer jock who was more than a lot of talk. He was an all-star out on the field. But with wits he had nothing to wield. He tried to act cool walking down the hall, but the coolest paid nothing to him at all. Top of the food chain, that's what he thought. Sneaking on up until he got caught.

Hey soccer boy the joke's on you, so get your stunt double for act two. Played your part, had a blast; too bad your part didn't last. It seems to be the common trend - and now we're waiting for the act to end.

Sam was a preppy girl, who loved earrings and the pearls. She spent her time wasting her brain. 24/7 on the popular train. Her head was like a hot air balloon. For knowledge, there was no room. Changing clothes just to fit in - going out of style was a total sin.

Hey preppy girl the joke's on you, so get your stunt double for act two. Played your part, had a blast; what a shame your part didn't last. It seems to be the common trend - and now we're waiting for the act to end.

Alex was a nerdy guy, couldn't fit in if he tried. Computer guru, master of his craft; but when he walked down the hall they all just laughed. He was at the bottom of the totem pole- Their leering jabs reached to his soul. They made fun of him to the bitter end. His broken spirit will never mend.

Hey nerdy boy the joke's on you, so get your stunt double for act two. Played your part, had a blast; too bad your part didn't last. It seems to be the common trend - and now we're waiting for the act to end.

Sarah was a gothic girl, who took her life like the tilt a whirl. She spent her days avoiding the cool; hated everything that had to do with school. Her favorite colors were black and gray. Though she was shunned she always made the grade. She loved the dark, hated the light; every new day was a different fight.

Hey gothic girl the joke's on you, so get your stunt double for act two. Played your part, had a blast; what a shame your part didn't last. It seems to be the common trend - and now we're waiting for the act to end.

Society is too cool to blame, so we honorably mention all its shame. It took each kid for a different ride. Each screw up never hurt its pride. All it wanted was to make things good; like any dysfunctional parent would. In hindsight it made things worse. But it left room for another verse.

Hey society, the joke's on you. And you don't have a stunt double for act two. Played your part, had a blast; what a shame your part didn't last. It seems to be the common trend - and now we're waiting for the act to end.

## Mad Lullaby

I'm trapped in a prison of my own design; locked behind bars
inside my mind. Freedom is a figment of reality;
imaginary escape as far as I can see. Jealous of the birds that
flauntingly fly, defeated by gravity whenever I try.
Plotting a route that doesn't exist, ignoring the exit signs
inside my wrists. Insanity creeps like a timid spider,
the knot in my heart is growing tighter. The voices within whisper
commands; it's getting harder and harder to ignore their demands.

The days by now are an incalculable number, and now I lay down
so that I may slumber. Dream of a freedom outside of my head;
dream of a freedom reserved for the dead. As my eyelids grow heavy,
I slip into bliss. Deliverance from hell is all that I wish.

## My Monster

Pillow talk is wasted when falling on deaf ears. I tried convincing myself
to ignore my deepest fears. I close my eyes to hide, and yet you're still
right there; to see you face to face is more than I could bare.

You're the monster underneath my bed, but I wouldn't trade you for a thing.
You're the monster hiding in my head; my biggest fear is of you leaving.

Don't pay any mind, I'm just a closet case; hiding with skeletons
that can't show their face. Ask me to stay, and I'm your's for the
taking. Ignore those sounds of my insides all breaking.

You're the monster underneath my bed, but I wouldn't trade you for a thing.
You're the monster hiding in my head; my biggest fear is of you leaving.

Riddle me this, why are you still around? Haven't you stolen everything
that you found? Or is it too much that I can survive? Is that not something
that you could contrive? I'm battered and broken, but conscious
and breathing. Is it not enough until you leave me bleeding?

## No Chance

You'd better save your smile for someone that cares. You'd better not be looking with a longing stare. You had your chance quite a while ago, a thousand times you ask, a thousand times no. The scar in my back still runs deep; I trusted you with me and my heart to keep. Instead you took a knife and thrust it in - falling in love with you was such a sin.

If I close my eyes will you go away? It hurts so much more to see you every day. I don't understand your train of thought. You're the one that cheated, and you got caught. Why come around pretending we're the same? I'm tired of playing your stupid mind games. Just pull your knife out of my back; I care for you like a heart attack.

One day down the road, our paths will meet - we'll stare at each other from across the street. A boy in your arms, a girl in mine, we'll nod at each other and pretend to be fine. Somewhere in our hearts we were meant to be. But now we're just lovers who were lost at sea.

## Once

Far away from the place I called home, even with you around I am alone.
I stare in the mirror at the empty in me; arguing with demons, begging
to be free. Persuading myself that things pass with time; convincing
myself that I will be fine. Shards of glass rip through me as if it were
rain. I embrace the despair and ignore the pain. My tunneled vision
fades to black, secretly wishing to never come back. As consciousness
trickles back into my mind, I find myself saved one more time.

## Picture Perfect

These pictures here up on the wall, they mean nothing to you at all. Just
rip them up and tear them down, watch them drift right to the ground.

Our history has been erased, being with you was such a waste. We should
have moved at a slower pace, or not have started in the first place.

So just take my broken heart-shaped frame, and look around when
you do. See that there is no one to blame, nobody but you.

The pictures that you said you'd take, in the city, by the lake. There was always
only one flaw in all of these. Every time the only flaw, the only one was me.

All the memories have been erased, the time we spent was such a waste.
Should have run faster in this race, finally finished, but took last place.

Just take my broken heart-shaped frame, look around when you
do. Find that there is no one to blame, nobody but you.

## Pot of Gold

This tapestry of a fragile mind has affected me in the worst kind.
Your sympathetic irony has finally gotten the best of me. You've
dragged me down every time, but finally, I'm no longer fine. Now I see
from your perspective; now I see why you're protective of something
that you hold so dear. Now I see that there's nothing here.

I'm sorry, but your pot of gold is under a different rainbow. And
no matter where you go, disappointment will always follow.

Your confusion is now making sense, but it'll soon be put into past tense. No
more holding it over my head, you can miss me when I'm dead. I'm finally
sick of falling down, I'm finally tired of being your clown. I'm finally done
with all your games, I'm finally bored of your false claims. You may say that
this is a moral outrage, but you're just jealous 'cause you got upstaged.

I'm sorry, but your pot of gold is under a different rainbow. And
no matter where you go, disappointment will always follow.

Your tapestry has just come undone, you've lost your mind, wasn't it fun? You've
lost your power over me, but 'tis I who fills with envy. I'll never know the joy of
careless, nor the love of unhappiness. I'll never taste the bittersweet; I'll never
sit in the pilot's seat of this crazy, mixed up plane - one way trip to the insane.

I'm sorry, but your pot of gold is under a different rainbow. And
no matter where you go, disappointment will always follow.

## Russian Roulette

Click click
goes the barrel of the gun- holding to my head for the pleasure of the fun. I'm
one step from being on the run. And they tell me that I'm crazy, that my mind's
an open sore. They tell me that I'm lazy, and the clean ups such a chore. Don't
push me now, I'm on the brink. Don't look now, bending over the sink. The clock
has stopped on the minute hand; I'm ready to jump with nowhere to land.

Click click
goes the chamber of the gun- holding to my head the deed is almost done.
One more step and then there will be none. But they tell me that I'm crazy,
that none of this is real. And now my vision's goin hazy, hardly have to feel.
Don't push me now, I'm on the edge. I'll finish soon, this I pledge. The clock
has stopped with time to spare; when I'm gone, you won't even care.

Click click
goes the hammer of the gun- holding to my head, the countdown has begun.
One last step before the midnight sun. But they tell me that I'm crazy,
that I've finally lost my mind. And they tell me that I'm lazy, I am running
out of time. Don't push me, I'm going now. I've taken all that was allowed.
The clock has stopped just in time; now I must commit this crime.

Click click

## Shattered

Shaken, but never stirred awake. I promised that I would never break. Caught off guard by the cards I was dealt; can't lose these feelings that I've never felt before.

I close my eyes as I fall through the floor. The days have numbed
me with a shell - I beg for freedom from this hell. I hold my breath
till there's no breath left. I hold my breath till I'm laid to rest.

## Snapped

Horribly sadistic, time to go ballistic, everyone get out of my way. I
lost my mind now I'm out of time, why am I the one to pay?

My soul's a fiddle, my heart is scarred. We tried too much and we got too far.
Nobody can blame us, except ourselves. Set aside strife, put guilt on shelves.
Where are we going, where have we been? In this game of life, can nobody win?

Why does it hurt, what was the worth, we knew the pain all along.
The people pray, beg us to stay, tellin' us to be strong.

But what we see cannot be, the same as them out there. We're gonna
snap at the drop of a hat, one thing we don't know is where.

My soul's a fiddle, my heart is scarred. We tried too much and we got too far.
Nobody can blame us, except ourselves. Set aside strife, put guilt on shelves.
Where are we going, where have we been? In this game of life, can nobody win?

In this game of life, can nobody win...?
In this game of life, can nobody win...?
In this game of life, can nobody win...?

## Something Missing

I'm just a soul who's lost at sea, So why does everyone want to be me?
What's so great about being a zero? Wouldn't you rather be a big hero?

Day in and day out, they tell me to be thankful, but I resent them and turn
out hateful. You tell me how great I have it, but there's one thing you don't
see. I'm losing my sanity bit by bit, the person I hate the most is me.

I know how "great" I have this life, but all I see is the daily strife. I look for
the good in all the people I meet, but the one person I don't... is me.

I hold inside me anger and pain, and one day the blood will come
pouring out like rain. You tell me not to take this life for granted, you
tell me that everything will be okay. but the problem is, is that I'm
stranded, and when the clock chimes, I'll be the one that pays.

## Stairs

It's the brink of defeat that pushes us through. The words that beat
us black and blue. I'm sorry kid, but I'm sitting this one out; you
cast the shadow right over my doubt. I held my head high as you
waved goodbye. I held my tongue back as my heart cracked.

I feel that I'm falling down an endless staircase, and all that
haunts me is your broken face. I scream for help, but no
sound escapes; I close my eyes and embrace my fate.

It's the hope that we cling to that keeps us alive. The words are the
things that help us survive. I'm sorry kid, but I'm sitting this one out;
if only you knew what the game was about. I held my eyes closed as
the lies were exposed. I held my fists tight so as to not fight.

I feel that I'm falling down an endless staircase, and all that
haunts me is your broken face. I scream for help, but no
sound escapes; I close my eyes and embrace my fate.

## Terminal

I feel myself slipping into a terminal state, your well  placed
words are just a minute too late. There's no shame in the scars
on my wrists; forgive and forget are on the top of my list.

Blink once, blink twice, and then I'm gone. No more long nights asleep on your
lawn. The shadow of doubt was eclipsed by the sun, and now the truth has been
told. It wasn't just your eyes that were wondering, and now I'm left out in the cold.
Though my days are longer without you, I'm afraid, my dear, that we are through.

I still see you, every once in a while. It seems broken hearts are
back in style. But the grief outweighs any pain that you caused,
when all we were was a lie. Although your denial of this is pathetic,
I can't help but find it a bit wry. Even with the humor, I still hurt
deep inside. I suppose that's what happens when lovers collide.

I feel myself slipping into a terminal state, your well-timed
words were just a minute too late. There's no shame in the
scars on my heart; I'm the one that tore us apart.

## The Phrase

Am I just here for your convenience? With whom do I file grievance against
the crime that you've committed? The truth of you has been omitted. You can
kick and scream all you want, but you really should hide the nonchalant.
I can do what I want, laugh or cry, but it does me no good to live this
lie. Our love was tragedy wrapped up in a pain. I've decided that I never
want to see you again. I'm sorry my friend, but this is the end.

Am I just here to keep you gained? No longer will your guilt keep me
chained. I'm pretty sure I can think for myself – how about you put your
pride back on the shelf? You have no need for it now anyway; your heart
will be broken within a day. I'm not worried, because it's not my fault. I just
decided to make this all halt. I promise that you can find somebody new.
So here I stand, bidding adieu. I'm sorry my friend, but this is the end.

## The World No One Saw

What if the world came to a halt? Where would the masses place the fault? Would they blame their shortcomings, or the way they behaved? Would they pin it on those who have become enslaved to TV, to food, and vices alike? Or would they pass the folly onto the media's Reich? People pass the blame like a hot potato; they hide themselves wherever they go. Sitcoms of satire, real life on TV. Those glued to the screen that claim to be free.

Our super sized lives come made to order; shorten your lifespan
for only a quarter. Caution thrown to the wind,
good health down the drain. Trying to maintain has become
such a pain. If there's something you don't like,
you can have it erased. Tummy tucked, hair replaced,
you can even have them lift your face.

Society itself is being reformed, but Man's good will is being deformed. All that had beauty is now in ash, sitting at the bottom of the trash. They stepped on the little people, digging them into the ground. The world's heart broke without making a sound.

## Time Up

A tender heart of complacency, an unending desire to be set free. Someone undo this hold of irony; the blind lead the blind straight into the sea. I've turned my back on this hypocrisy - when this house of cards fall, don't come look for me.

An unwavering dawning of the times, the criminally insane are the ones deemed fine. Here I stand as I'm losing my mind; blissful ignorance draws the line.

The haughty yawn as they shake their heads; an unspoken prayer for their beaten dead. Eggshells shall litter the hollow ground we tread; the blind open their eyes to see where they're lead.

When it's all said and done, our stomachs shall churn. We regret the outcome, but we'll never learn. The black and the white are hard to discern; the gray areas left are all that we yearn.

## Travesty

Watch out now, tragedy in the making. You all saw, but thought that I was
faking. Will you be around when I fall to the ground? Can you promise
to catch or will you just snatch my dignity away  like the other day?

I'm tired of your head games, you should really be ashamed. Is this your
claim to fame when you change your name? Can you promise to stay
when I ask you to play with my head again because I love to sin?

You should take care when you play with fire, especially when it takes you higher.
What would you do if I knocked you off your high horse that loves to scoff? Can
you promise to cry when you lay down and die from embarrassment of retirement?

# LIFE / IN BETWEEN

"Life is what happens to you
while you're busy making other plans."

~John Lennon

# A World Apart

A secret wish to be with her; my restless heart makes me stir. I feign a smile when she passes by, I convince myself to live a lie. All the boys she picks, deserve her not. They'll never learn that she can't be bought. I've spent my time as a labeled friend - I stand by her until the bitter end.

As days pass by like grains of sand, I find it difficult to even stand.

I tell myself that this time is different. I trick myself to ignore
the dents that she left in the reaches of my heart.
I'm standing right beside her, though a world apart.

I grit my teeth as she holds his hand. I swear one day I will
be that man. Until that point I'll stand idly by;
being her shoulder when he makes her cry. I'll put her back together
when she falls apart. Then we'll return back to the start.

The days still sift like grains of sand, and I find it difficult to even stand.

I tell myself that this time is different. I trick myself to ignore
the dents that she left in the reaches of my heart.
I'm standing right beside her, though a world apart.

# Blindsided

I'm just a poet who didn't even know it 'til the age of thirteen. Strange
as it sounds I rapidly found that I wasn't too keen on the idea of
sharing my mind. At least not through this method of kind.

I tried to ignore it, it drove me insane. It quickly appeared as
something so plain. Drilled in my head, these words always
came. Every time I ignored them, the crime was the same.

Something so simple, yet so hard to grasp. Tortured my soul, and kicked
my ass. These words they echoed through my brain. And all that it
caused was mental pain. But that was enough to start this cascade;
the thoughts started dancing like some sort of rave. Bouncing from
one end to the other side, I needed an escape, a place to confide.

Finding no outsource, the words they ran loose. Then all of a
sudden, I was riding a moose. You may be asking why it was a
moose. It was the best thing that rhymed with loose. But that is a
story for another time. Let us get back to my little rhyme.

The words were loose, running rampant and free. They were rapidly
committing a mental killing spree. Headaches ensued, that turned
to migraines. I look back now, and think 'that was lame'. But once
again, I'm getting off track. I should lay off all of that crack.

Don't stare me down, I don't really do drugs. When given the option,
I'd rather take hugs. I'm merely trying to make a point. Which kind
of sucks 'cause there's no rhyme for point. But back to the story of
my poetry woes, and how they became my most hated foes.

Don't get me wrong, my poetry's fine. But you have to admit, they can cross the line. I'm breaking down walls, and I'm taking down names. You'll none be remembered when I finally reach fame. But that's all assuming that I get rich quick; and it's definitely not helping that I'm getting so sick.

Off topic again, must be loosing my steam. I'm not a good train, if you know what I mean. Too many seats, but no one to fill 'em; Whenever they get on, I always derail and kill 'em. See how I personified my train of thought? Bet that's something your school never taught. I'm a master of disaster, you've got nothing on me. Guess you'll never know the story of my poetry.

## Empty Car

The days are longer but I've lost count, don't lose sleep on my account. I
remember the days that you spent with me. I remember the days that we were
free. Sneak a glance and steal a kiss; those are the days that I most miss. But
now you're gone, don't know where you are. I stand here waiting by an empty car.

The world was ours for the taking. The feelings there were
never faking. When I held your hand in the dark,
I could always feel just a little spark. We'd stare at the stars up in
the sky, we'd hold each other and close our eyes. But dreams wake
up, and leave deep scars. I stand here waiting by an empty car.

I know one day you'll come back, I hope that I'm something that you lack.
I'll stand here waiting by my empty car; ready to give you all the stars. The
very same ones that were in the sky; the very same ones that could never
lie. I'll stand here waiting just for you. I hope you're waiting for me too.

# Go For Broke

When the flag is dropped, all bets are off, just pray that you don't
choke. Hit the gas, drop the clutch, this time we go for broke. Cruising
down the Seven Nine, so far everything is going fine. Check the
rear, the heat is on. Keep your eyes on 'em, or they'll be gone.

Gear it up, let it roar, let that peddle hit the floor. The scenery around
you starts to blur, but all you care about is that engine purr.

When the flag is dropped, all bets are off, just pray that you don't
choke. Hit the gas, drop the clutch, this time we go for broke.

Take the turn down the Eighty Two, bid your competition a fair adieu.
Blow 'em away with a Nitro burst; smile and wave as you fly to first.
Switching up the gears again, the cars behind begin to gain - faster and
faster, the race moves on. Just a little further, and you'll have won.

When the flag is dropped, all bets are off, just pray that you don't
choke. Hit the gas, drop the clutch, this time we go for broke.

Comin' back to the Seven Nine, you keep your eye on the finish line.
With mere seconds before the end, you make your way around the
last bend. Push the peddle to the floor, you're not playing anymore.
With the way your car ran, the race was over before it began.

When the flag is dropped, all bets are off, just pray that you don't
choke. Hit the gas, drop the clutch, this time we go for broke.

## LHS (Lonely Heart Syndrome)

Home is where my heart is, but I'm a million miles away.
Now I feel like I am empty, and I don't know what to say.
My heart beats as I march in time. But the distance feels like such a crime.

I want to hold her in my arms; I want to keep her safe from
harm. But there's a whole lot of road between me and her.
When I think about the loneliness, it causes me to stir.

I close my eyes as the days drag on; I grit my teeth and keep on singing this song.

Home is where my heart is, but I'm a million miles away.
Now I feel like I'm empty, and I don't know what to say.
I want to be there in case she breaks.

I want to help her through her mistakes. I would hold my breath just to
be with her. When I think about the loneliness, it causes me to stir.

## Liberty

I stand alone on this battlefield, though I have no weapon I can wield. Ashes and dust of my fallen friends; I beg to God, this nightmare to end. We started a war in the name of peace; to give life a chance to renew its lease. Our flag of white, blue and red droops with remorse for all the dead. The price for freedom is growing steeper, brothers in arms are the Lady's keepers. Soldiers fighting for their right to go home; when it's all said and done, I stand alone.

# My Masterpiece

Have I ever told you of my great masterpiece? It was all about
a knight, and a giant beast. When it was first written, it was
my best to date. Sadly I was unaware of its horrid fate.

It started like any other night, a quarter just past three. I found my little
doggy tied up to a tree. I wasn't sure what happened, but I knew that I
must cut the rope from up upon the tree, and free my stupid mutt.

So I began to cut the rope in the middle of the night. And as I was saving him,
his eyes did fill with fright. I turned around abruptly, not expecting what to see.
There stood a giant monster, looking down at me. Its skin was made of scales, its
flesh, it smelled of pine. My eyes began to whelm with fear as I began to whine. I
begged and pleaded with the beast, asked for a chance to live. The beast let out
a mighty roar and asked what I had to give. I pondered this long and hard, but
nothing came to mind. He told me that he'd give an hour for me a thing to find.

Thanking him at once I raced off for my home. There I dug and
searched through all the junk owned. Once again, nothing found,
my time was running low. The beast would be returning soon, and
then I'd have to go. Like a revelation, I knew what to give the beast.
I would give my favorite thing, I would give my masterpiece.

The clock did make a chirp, as the time read five. And just as it had said, the
beast, it did arrive. Its claw outstretched in waiting, I sighed in dire fright. I gave
to him the giant beast, and the noble knight. The beast's eyes bulged a bit as it
stared upon my tome. Suddenly the sun did rise, and turned the beast to stone.

That was the story of the mighty beast, and how it had stolen my masterpiece.
The statue of it is still on display. But I made the best of it, and make people pay.

## Poetic Justice

Roses of red, violets of blue lilies of white, you know it be true. What has the price of freedom become when it is common to lose a loved one? What has the price of freedom become when you lose hold of a dear one?

So cover the caskets with roses of red, violets of blue and lilies of white. So whisper a prayer for the fallen dead, and ask yourself if it's worth the fight. Why has the price for freedom arrived to a place where the living aren't even alive? Why has the price for freedom arrived where all but a few were chosen to die?

Just hold in your hand a violet of blue, a rose of red and a lily of white. Just know that there was nothing to do that could change the result of this fight. When will the price for freedom fall to a place that can be called? When will the price for freedom fall where we can stand one for all?

# Pretty Girl

Streamers up high began to fall; she was the prettiest girl at the ball.
She made her father proud, and her mother cry. She gathered quite the
crowd when she started to die. 'Her heart just gave', said the doctor then.
It was a sob-filled room when they said 'amen'. The casket closed, and
they lowered her down. They buried her in her most favorite gown. It
was a fitting end for a fairy tale. Fate struck its chord without fail.

Pretty girl, why'd you have to go? You should've taken things
much more slow. But now you're gone without a goodbye.
We'll know you're always watching from the sky.

Her friends from school all said prayers - who would've known so many
cared? Her father broke down, her mother too. They wore their frowns through
and through. The air of sadness stayed for quite a while. You'd think such
a mood would go out of style. Parents blamed themselves for the way they
fought; didn't even notice all the stress it brought. Their daughter's death,
they blamed themselves - convinced that they were condemned to hell.

Pretty girl, why'd you have to go? You should've taken things
much more slow. But now you're gone without a goodbye.
We'll know you're always watching from the sky.

Pretty girl, you didn't have to go. We all should've taken things
much more slow. But now you're gone, didn't say goodbye. At
least we'll always know you're watching from the sky.

**Rainy Day**

It was a stormy night on October the 3rd; you stood before
me, but said not a word. You whispered 'I love you' just before
dawn - I told you I loved you, but you were gone.

And now the rain still stings like tears, perhaps you'll return in another year.
When that comes will you remember then? When you get back, will we still be
friends? Maybe we'll have to start over again? Worst of all, will our love end?

I'll be ready next time, when you get home. But there's no
guarantee that I'll be alone. You asked me to wait for so long.
It's hard to keep a promise when you've been gone.

And still, the rain stings like tears, I hope you'll be back by
next year. When that comes will you remember then?
When you return, will we still be friends? Do you think we'll have
to start over again? Do you think... our love will end?

All my unopened letters on your countertop - you didn't have
the heart to tell me to stop. So all of my feelings were lost
to you. Maybe you can tell me why I'm such a fool?

To this day, the rain stings like tears. Secretly I hope you're not
back next year. But if you come home, will you remember then?
When you return, do you want to be friends? Are you going to
start all over again? Or do you just want this all to end?

## Shadows on the Moon

The castle floated on the clouds, as dusk it did draw nigh. The dwellers of this mighty hold, did hold themselves on high. T'was night hence came the creatures, shadows tracing on the moon. Requiems of fallen soldiers spelled a certain doom. Though the dwellers slept content, their dreams were soon assailed. Though dream catchers stood as guards, the very same had failed.

None were safe from anything, on that fateful eve. And those that tried to fight the beast, the shadows did deceive. Torn away from families, the dwellers then did cry. Trembling and fearing, certain they would die. Moans and screeches from the fallen soon did enter ears. The shadowed monsters still were growing, feeding off the fears.

Chaos coming, all was lost, nothing could be saved. The shadows all were hurried, digging all the graves. One last shadow drifted, all along the moon. The dwellers saw this coming, and knew that it'd end soon. The shadow was a blanket, choking every light. With a lasting final breath, screams echoed through the night. As the shadow faded, t'was nothing left around. And soon the castle fell asunder, and crumbled to the ground.

## Shakespearean Irony

A chance encounter at the dance, stumbled into possible romance. To talk with her, he dare not ask; his affection refused to hide in the mask. Few words were spoken, but they'd suffice. Their secret kiss soon became a vice.

He snuck out that night to see her once more. He realized he knew her from somewhere before. Their families were feuding, and had reached an impasse; he feared that their love would just refuse to last. Star-crossed from jump street, but he didn't care. He knew that they made the most perfect pair.

The fighting families then took a violent stand; her brother's blood was on his brother's hands. A plan was then hatched so the two could escape. A better future tomorrow that they could both make. A secret that involved the illusion of death. A promise to reunite as she drew her "final" breath.

But even with some of the best laid plans, fate finds a way to slip out of our hands. Though her death was fake, he didn't know. Thus ends the life of her one true beau. With a kiss of steel, she fled the mortal coil. Such true love could never be spoiled. For never was a story of more woe than this of Juliet and her Romeo.

## Stars

Your laughter still echoes in my ears, my mind tricks my body into thinking you're still here. You've been gone for a while, but the memories are fresh. I remember the day that we laid you to rest. The rain was coming down like tears from above; a sympathetic thunderstorm for my departed love.

At night I still feel the warmth of your breath, casually caressing the back of my neck. The nights are long when I lay down my head. I try not to think about my big, lonely bed. My heart starts to ache when I hear our favorite song; the only words I hear are how you've come and gone.

I know you're in a better place, but it hurts all the same.
My young, naive heart never knew such pain. But worry not my love, for I will carry on. I promise I will make it; I promise I'll be strong. One day we'll reunite high above the stars. Until then I can wait; the day cannot be far.

## The Last Days of Humpty

Humpty Dumpty sat on his wall. The wind picked up and he started to fall. Panicked and scared as he careened to the ground, he frantically reached for something around.

Sadly, t'was nothing to stop his decent. Nothing to stop him, except the cement. The King sent his horses, the King sent his men. He charged them with putting Humpty together again. The men they worked hard, and all the night through. Nobody was quite sure what the horses could do. They all tried their best, but t'was all for naught. So they scrambled him up, and Humpty fed the lot.

## Tranquil No More

Someone once showed me the way to your heart. But lost in translation, it all fell apart. So now I spend my days, wandering alone. And now I spend nights with nobody home. But the dark, moonlit air can't even compare to the pain that's inside that came when you cried. I know what I've done; I know that it's wrong. I know I'm not deserving of your sweet song. But I ask away, because it burns so deep; I ask anyways, because I can't get to sleep. Restless, hopeless, filled with despair. Now you're gone, and life isn't fair. Petals of roses that fall to the ground. Remnants of you that were never around. I'll close my eyes and wake from this dream. I'll close my mouth and stifle my screams. I'll count the seconds on the minute hand; I'll count the moments that we never had. Remember me for all the things above. Remember me dear, my sullen love.

# Thrifty

All these multi-colored cultures, swarming us like a pack of vultures. Trying to sell us their useless crap, everywhere you go, just another trap.

In your pocket, that 50 dollar bill burns a hole even brighter still. That Ben Franklin begs to be spent; doesn't matter, as long as you make rent.

The consumer gods ask that you spend everything you've got 'til the bitter end. Just blow your paycheck down the drain, hit the pavement so fast gonna leave a stain. You're helping the economy, that's what they say. But you're losing your money before you get paid. The consumer gods have hit the lottery, payable by you and me.

With bills to pay piling high, your tax forms are filled with lies. Looking for a buck here and there - try not to let the gods watch and stare.

Our goal in life is to please the consumers and their needs. But doing this is no easy task. Why we do it, we don't even ask.

So just blow your paycheck down the drain. You're going so fast you're gonna leave a stain. You're losing your money faster than you get paid. You're not helping the economy, that's just what they said.

# Un

The shadow perched atop the rim, moonlight gleamed off its toothy grin. Its
eyes watched, waiting, biding time; weighing consequence of its crime. The
village below slept unknowing. The shadow's excitement was ever growing.
With a final pause, the creature leapt. It streaked the sky like a falling jet.

Its roar ignited a deep fear within. The masses awoke to the ensuing din. The
world then stopped for just a tick - long enough for the effect to stick. The
land was lost in a choking black, completely defenseless against the attack.
Echoes of screams rang through the night. The
slivers of hope were dragged out of sight.

But all at once, the creature grew weary; its mind was filled with something
dreary. A splash of light broke the monster's grasp - the sudden act
caused the creature to lapse. The shadow was ripped down to its core,
the sun smeared the grin that it wore. With a deafening howl, the dark
faded away. The village of Un was spared for a day. But the shadow
waits for its night to come; a time and place when there is no sun.